A Kid's Guide to Drawing the Countries of the World™

How to Draw

Hungary's

Sights and Symbols

Betsy Dru Tecco

The Rosen Publishing Group's

PowerKids Press™

New York

For my Hungarian stepfamily: Richard, Jamie, Sue, and Carol Howarth

Published in 2005 by The Rosen Publishing Group, Inc.
29 East 21st Street, New York, NY 10010

First Edition

Editor: Rachel O'Connor
Book Design: Kim Sonsky
Layout Design: Albert B. Hanner

Illustration Credits: Cover and inside by Holly Cefrey; p. 18 by Albert B. Hanner
Photo Credits: Cover and title page (hand) Arlan Dean; p. 5 © Bettmann/Corbis; p. 9 © Adam Woolfitt/Corbis; p. 10 © Dave Bartruff/Corbis; p. 12 courtesy of the Hungarian National Gallery, Budapest; p. 13 courtesy of the Hungarian National Gallery, Budapest. Photo by Tibor Mester; p. 14 © Geo Atlas; p. 16 © Eye Wire; p. 20 © Joel Sartore/Corbis; p. 22 © Roger Tidman/Corbis; p. 24 © Michael St. Maur Sheil/Corbis; p. 26 © Wolfgang Kaehler/Corbis; p. 28 © Carmen Redondo/Corbis; pp. 30, 32, 40 © Carmen Redondo/Corbis; p. 34 © Vittoriano Raselli/Corbis; p. 36 © Dave Bartruff/Corbis; p. 38 © Paul Almasy/Corbis; p. 42 (left) © Catherine Karnow/Corbis, (right) © David Greedy/Lonely Planet Images.

Library of Congress Cataloging-in-Publication Data

Tecco, Betsy Dru.
How to draw Hungary's sights and symbols / Betsy Dru Tecco.— 1st ed.
 v. cm. — (A kid's guide to drawing the countries of the world)
Includes bibliographical references and index.
Contents: Let's draw Hungary — More about Hungary — Map of Hungary — Flag and currency of Hungary — Coat of arms — Sunflower — Great bustard — Roman ruins at Gorsium — Statue of St. Stephen — Pannonhalma Abbey — Royal Palace — Statue of Janos Hunyadi — Esterhazy Castle — Esztergom Cathedral — Great Reformed Church — Chain Bridge — Opera House.
ISBN 1-4042-2737-7 (Library Binding)
1. Drawing—Technique—Juvenile literature. 2. Hungary—In art—Juvenile literature. [1. Hungary—In art. 2. Drawing—Technique.] I. Title. II. Series.

NC655.T357 2005
743'.899439—dc22

2003023529

Manufactured in the United States of America

Contents

Let's Draw Hungary

Throughout much of its history, Hungary has been claimed by outsiders. From 35 B.C. until the late fifth century, Hungary was part of a province called Pannonia, which was controlled by the Roman Empire. For centuries after the fall of the Roman Empire, nomadic tribes from Mongolia, Germany, and other lands settled in the area. The most powerful tribe in the group was the Magyars. Led by Prince Árpád, the Magyars arrived in the 890s. In the year 1000, Árpád's great-great-grandson, Stephen I, was crowned the first king of Hungary. This event marked the birth of Hungary as a nation. The Árpád dynasty, as it was called, lasted until the early 1300s. Hungary was then led by rulers such as Charles Robert of Anjou and his son Louis the Great until Turkey conquered Hungary in 1526. The Turks ruled until 1699.

During the 1700s and 1800s, Hungary was ruled by Austria's Hapsburg Empire. Revolts against the Hapsburgs led to a dual monarchy in 1867. This meant that Hungary could operate as an independent country and still accept the Austrian emperor as king.

In this picture by N. Munkasky, Prince Árpád, the chief of the Magyars, is shown leading his people into Hungary around A.D. 895.

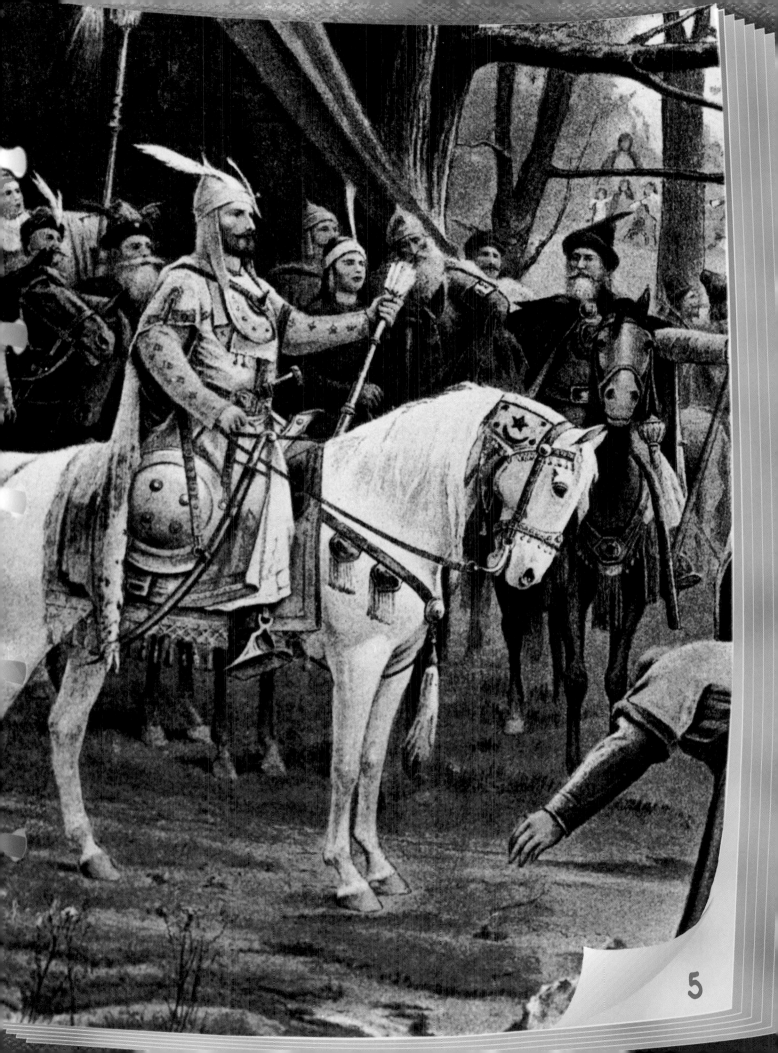

The dual monarchy ended in 1918, after World War I, because of revolts by Hungary's ethnic minorities, including the Slavs, who wanted to rule themselves. Hungary became independent, but it was now almost one-third its original size. After the war, a peace treaty called the Treaty of Trianon gave Hungarian territory to neighboring countries, including Czechoslovakia, Serbia, and Romania.

During World War II, Hungary was attacked by German troops. When Germany lost the war, Soviet troops freed Hungary from the Germans in 1945. The Hungarians formed a democracy, and the Republic of Hungary was proclaimed. By 1949, however, the Soviet Union had taken control. Hungary was then under Communist rule for the next 40 years. Under Communism, the government controlled everything. Hungarians could not own land and were not allowed to practice any religion. Most people were poor and out of work.

Revolts by groups of angry Hungarians put an end to Communism by 1989. The first free election in 55 years was held in 1990. The people voted for a parliamentary democracy, which is in place today. In this form of government, citizens elect members of

the National Assembly, which is like the U.S. Congress. The assembly appoints a president as head of state. However, it is the prime minister who holds the power in Hungary. The prime minister is elected by whichever party is in government.

In this book you will learn more about Hungary and how to draw some of the country's sights and symbols. Directions are under each step. New steps are shown in red. You will need the following supplies to draw Hungary's sights and symbols:

- A sketch pad
- An eraser
- A number 2 pencil
- A pencil sharpener

These are some of the shapes and drawing terms you need to know to draw Hungary's sights and symbols:

——	Horizontal line	⏢	Trapezoid
⬭	Oval	△	Triangle
▭	Rectangle	\|	Vertical line
▬	Shading	∿	Wavy line
∿∿	Squiggly Line		

More About Hungary

Hungary's population is about 10 million. About nine million are Magyars, or native Hungarians. The largest minority group is the Gypsies. The Gypsies, or the Roma people, moved to Europe from India around the second century A.D. In the past, they traveled in covered wagons from village to village, making music and selling goods door-to-door. As many as 400,000 Gypsies presently live in Hungary. Today, however, most of them have homes and work at regular jobs.

Manufacturing is a major industry in Hungary. Chemicals, textiles, leather goods, and electronic products are some of the main products. Hungary also makes machinery and transportation equipment. Another big industry is mining, although it has declined somewhat in recent years. Bauxite is mined for the nation's aluminum industry. Workers also mine manganese, which is used in steel production, and copper.

Hungary's capital is Budapest. It is the largest and most-populated city, with more than two million people. In 1873, the towns of Buda, Pest, and Obuda were joined under the name Budapest. The Danube River splits the city in half, with Buda and Obuda on the west bank and Pest on the east bank. Here you can see the Chain Bridge, which connects Buda and Pest.

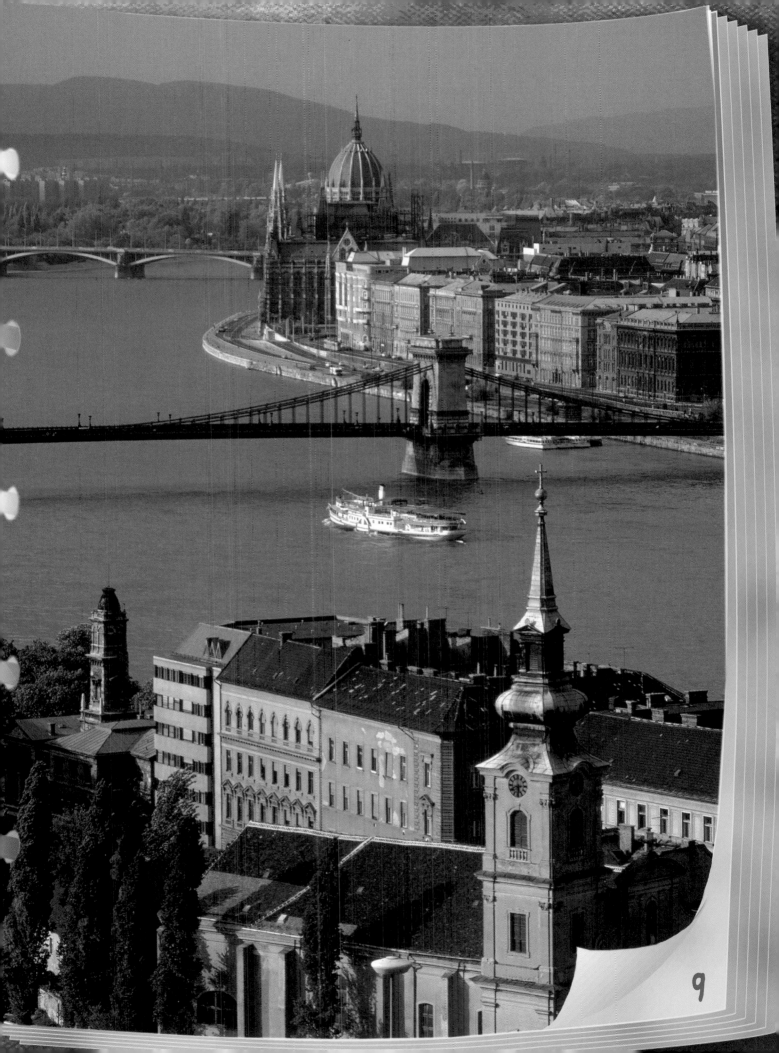

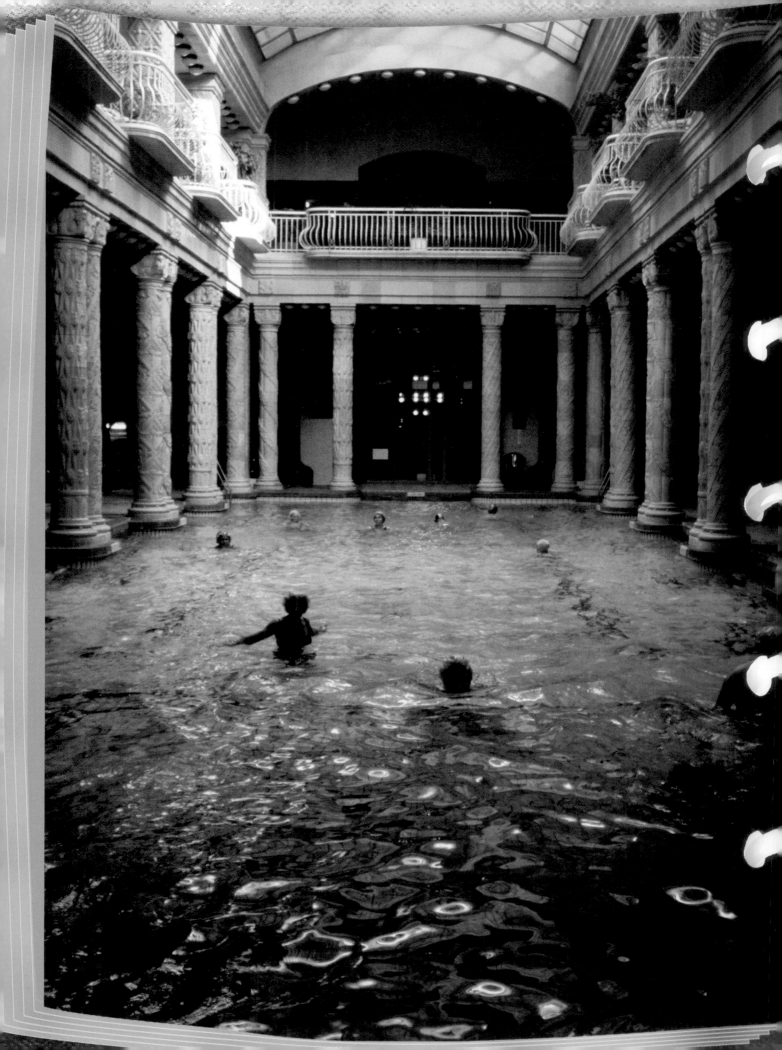

Agriculture is important in Hungary. In 1998, eight percent of the country's workforce was employed in agriculture. Hungary's main crops are wheat, corn, sunflower seeds, sugar beets, and potatoes. These crops are used for both domestic use and for export to other countries. Hungarians also grow about 10,000 tons (9,072 t) of paprika each year. Paprika, a dried red pepper, is the main spice used in Hungarian dishes. A popular dish called *paprikas csirke*, or paprika chicken, is made from chicken, onions, sour cream, and plenty of paprika. Fifty-five percent of the country's paprika is sold to other nations.

In 2000, Hungary celebrated its one-thousandth anniversary. Hungarians are hardworking people who want to grow as a free nation. Companies from around the world have invested billions of dollars to create jobs, which has helped the Republic of Hungary's economy to become the strongest in eastern Europe. In 2004, Hungary expects to join the European Union, which would bring support from other countries in Europe.

Hungary has more than 120 hot baths. The water comes from natural springs that lie beneath Hungary's surface, flowing with superhot water. It is believed that the water can improve people's health. Here bathers enjoy the indoor pool at the Gellert Spa in Budapest.

The Artist Laszlo Mednyanszky

Laszlo Mednyanszky

Laszlo Mednyanszky was born on April 23, 1852, in the Hungarian town of Beczko, which is now part of Slovakia. As part of an aristocratic family, Mednyanszky grew up with a lot of wealth. During his adulthood, however, he gave away many of his belongings, since he did not care about money. Instead, Mednyanszky gave his life to art. He went to school in Switzerland, Germany, and France. During World War I, he went to the front lines, where he drew pictures of men in battle. Many of Mednyanszky's paintings and pencil drawings realistically showed the suffering of soldiers, poor people, simple peasants, and Gypsies. It was the Great Plains of Hungary, however, that inspired Mednyanszky's earliest known pictures. His later landscapes captured the great beauty of the Tatra

12 Mountains with their snowcapped ridges, waterfalls,

and mountain lakes. For each painting, he made numerous sketches. Mednyanszky was especially interested in showing the effects of light on a scene.

By the time he died in Vienna, Austria, on April 17, 1919, Mednyanszky had become the most productive Hungarian painter of the early twentieth century. Private collections around the world hold nearly 4,000 oil paintings and several thousand drawings that Mednyanszky created. *Part of Taban*, the painting shown here, is part of the collection of the Hungarian National Gallery in Budapest.

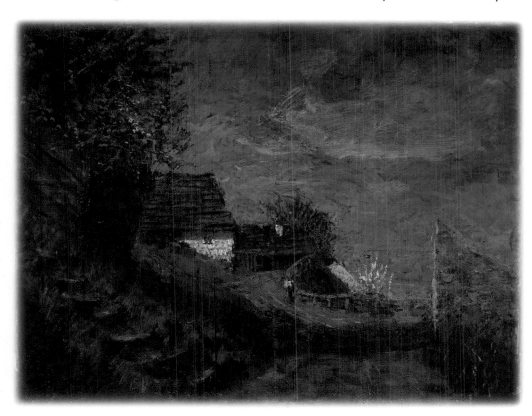

Mednyanszky painted *Part of Taban* in the early 1900s when he returned to Budapest. The pictures he painted at this time are characterized by dark colors and strong contrasts of light and shadow. This painting, done in oil on canvas, measures 16" x 20" (40 cm x 51 cm).

Map of Hungary

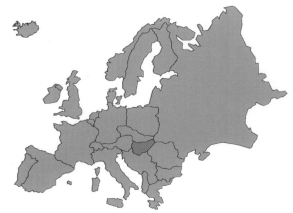

Map of the Continent of Europe

Hungary is located in the middle of Europe. It is a little smaller than Indiana, measuring 35,919 square miles (93,030 sq km). Hungary is surrounded on all sides by other countries. Slovenia and Austria border Hungary in the West. Romania borders it in the East, Slovakia and the Ukraine in the North, and Serbia and Croatia in the South.

The Great Plain, or Puszta, makes up almost half of Hungary. This low, flat area lies east of the Danube River. The Small Plain is in northwestern Hungary. Both the Small Plain and the Great Plain are used for farmland.

The Danube, the second-longest river in Europe, runs through the middle of Hungary. Hungary's longest river is the Tisza, measuring 359 miles (578 km).

14

1

Start by drawing an oval. Next draw the shape shown. This new shape is attached to the right side of the oval. These shapes will be your guides to drawing the map of Hungary.

2

Draw a squiggly line that runs in and around the oval as shown. Notice how it does not go around all of the oval. This is the western part of Hungary.

3

Erase the oval guide. Continue to draw the squiggly line around the straight shape you drew in the first step.

4

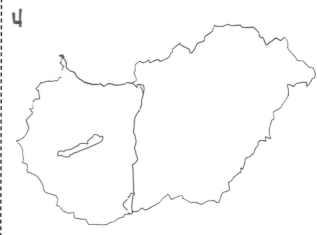

Erase the straight guide. This is the map of Hungary! Add the rough line going from the top of the map to the bottom. This is the Danube River. Next draw the shape to the left of the Danube. This is Lake Balaton. Lake Balaton is the largest lake in Central Europe, measuring 232 square miles (601 sq km).

5

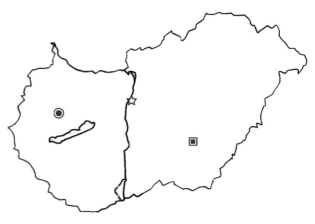

☆ Budapest (capital city)
〜 The Danube River
◿ Lake Balaton
◼ The Great Plain
◉ Roman Ruins at Gorsium

Finish by drawing the map key and adding the remaining areas of interest. These are Budapest, the Great Plain, and the Roman Ruins at Gorsium.
Well done!

Flag of Hungary

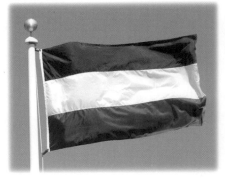

The flag of Hungary has three horizontal stripes of red, white, and green. The stripes are of equal size. The red stripe on top represents strength. The white symbolizes faithfulness. The green represents hope. This flag was first used during the Hungarian Revolution of 1848. During this revolution, Hungarian rebels tried to overthrow the Hapsburg rulers of the Austrian Empire, one of the largest empires in Europe.

Currency of Hungary

Hungary's currency is the forint. Forints first appeared in Hungary in 1325 during the Roman Empire. Until 1786, forints were made of gold. Since then the forint has been made in paper notes and silver coins. The 500-forint note features Prince Ferenc Rákóczi on one side and Rákóczi's castle in Sarospatak, Hungary, on the other. Rákóczi was a Transylvanian prince who fought for Hungarian independence from the Hapsburgs in the early 1700s.

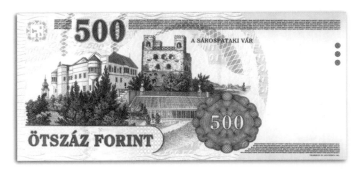

Flag

1 Begin your flag by drawing the flagpole as shown.

3 Draw two horizontal lines going across the flag. Notice how they are slightly wavy.

2 Draw the flag. Draw straight lines at the edge of the flag. Draw two small lines to attach the flag to the flagpole.

4 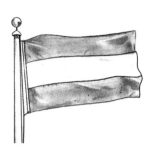 Finish your flag with shading as shown. Well done! You have drawn Hungary's flag.

Currency

1

Begin by drawing a large rectangle. Inside it, draw a circle and two shapes with straight lines beside it. On the left side of your drawing, draw a straight line that ends in a curve.

3

Erase extra lines. Draw small lines inside the top rectangles. Add details to the buildings. Add the bushes. Draw a squiggly line around the circle. Add the shape at the bottom right.

2

At the top of the note write 500, adding rectangles on either side. Next, write 500 inside the circle. Add lines inside the shapes beside the circle. Draw more lines on the left.

4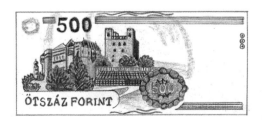

Erase extra lines. Using the photograph to help you, add as much detail as you would like. Finish with shading.

Coat of Arms

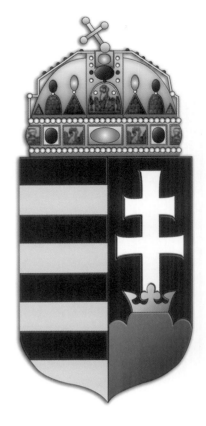

Hungary's coat of arms, also known as the small coat of arms, was established in 1874. It became the official Hungarian coat of arms in 1990, after the fall of Communism in Hungary.

The silver double cross on the pointed shield has been a national symbol for about 800 years. The cross stands inside an open golden crown, which rests on a hilltop. The three green hills symbolize the three main mountains of historic Hungary. They are Tatra, Fatra, and Matra. Next to the double cross are red and silver stripes called Árpád's Stripes, named for Prince Árpád. The four silver stripes represent the four main rivers that were part of Hungary's territory before the country was divided after World War I. These rivers are the Duna, or Danube, the Tisza, the Drava, and the Szava.

On top rests the Hungarian Holy Crown with its leaning cross. This royal crown represents the one that Stephen I, Hungary's first Christian king, received from Pope Sylvester II in the year 1000.

18

1

Start by drawing the the outline of the shield in Hungary's coat of arms as shown. Draw a vertical line down the center.

2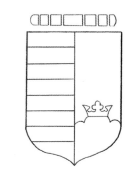

Draw seven horizontal lines to the left of the vertical line. On the bottom right, draw the crown and wavy lines as shown. The wavy lines are the three hills.

3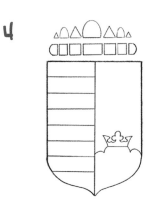

At the top of the shield, draw five rectangles and two half circles. These shapes are the start of the large crown at the top of the shield.

4

Add more shapes on top of the shapes you have just drawn. Four of these shapes are triangles. The other three are half ovals.

5

Draw three ovals in the rectangles above the crest. Draw four ovals above the top row of shapes. Add two shapes inside the largest half oval. Draw lines, circles, and ovals to form the shape at the top.

6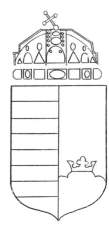

Draw two curved lines at the top of your drawing. Draw straight lines and two small circles to form the border of the crown. Add a cross, with a circle on each end, at the top.

7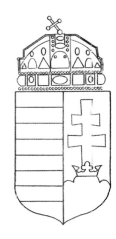

Draw a lot of very small circles above and below the row of shapes directly above the shield. Inside the crest, draw the double cross coming from the top of the small crown.

8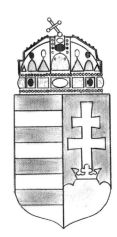

Add details to the large crown at the top of the crest as shown. You can finish your drawing by shading.

The Sunflower

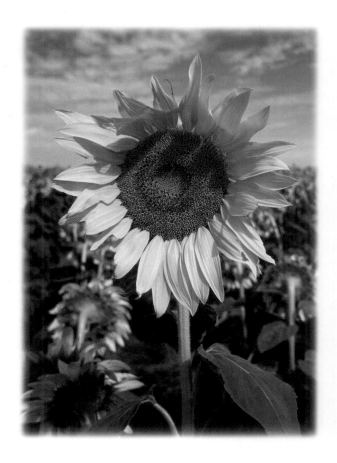

Sunflowers are giant flowers with many yellow petals and a thick stem. A sunflower's round head can grow to be as big as 2 feet (0.6 m) across. The plant itself can grow as tall as 15 feet (4.5 m).

Huge fields of yellow sunflowers cover the Great Plain, producing about 650,000 tons (589,670 t) of sunflower seeds each year. The seeds are allowed to dry on the stalk and are then harvested in September or October. They can be eaten as they are or can be pressed to a clear, yellow oil. Sunflower seed oil is used as cooking oil, in margarine, in salad dressings, and in soap. People love to eat roasted or salted sunflower seeds. Livestock and wild birds eat sunflower seeds, too. As well as being popular in Hungary, the seeds are also exported to other countries.

Start by drawing a circle. This will be the center of your sunflower.

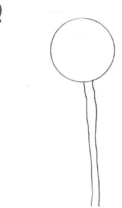

2

At the bottom of your circle, draw two long lines that are slightly bumpy as shown. These lines will be the sunflower's stem.

3

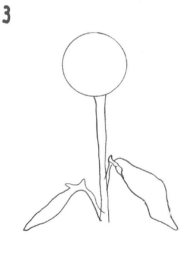

Draw two leaves, one on the left side and one slightly higher up on the right side. Look at the photograph of the sunflower on the opposite page for help.

4

Erase extra lines. Draw petals around the top of the circle. Notice that the petals overlap because there are so many of them.

5

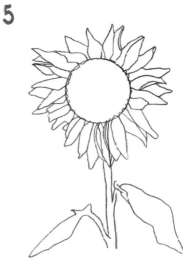

Erase extra lines. Draw more petals on the bottom of the circle. Again, the petals will overlap.

6

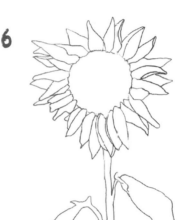

Erase the parts of the circle and the stem that are under the petals.

7

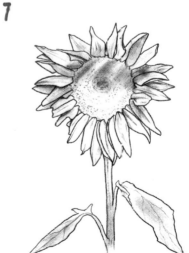

Add shading and detail. Well done! You have finished drawing the sunflower.

The Great Bustard

The great bustard is the national bird of Hungary. It is also one of Europe's largest birds. The males grow to be more than 3 feet (1 m) in length. Their wingspan can measure up to 7.5 feet (2.3 m), and they weigh up to 40 pounds (18 kg). The

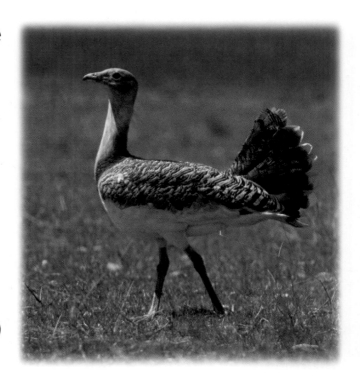

birds are related to cranes, but they have a rounder body, a thicker neck, shorter legs, and a shorter beak. Only about 30,000 bustards remain in Europe. Eighty percent of the bustards live in Spain and Russia, but about 1,200 live in Hungary. They are found on the ground on open plains and fields. The population is getting smaller because the bustards' home is being taken over by humans for farmland and other uses. Hungary's first national park, Hortobagy National Park, is a protected site for bustards in the Great Plains. Hortobagy has forests, large ponds, marshes, and flat grasslands.

1

Begin by drawing a small oval.

2

Draw a large oval. This shape will help you draw the great bustard's body.

3

Connect the small and large ovals to form the shape of the neck. Draw the shape of the body using the large oval as a guide.

4

Erase the guidelines, leaving the head, neck, and body as shown. Add five lines to make the shape for the tail.

5

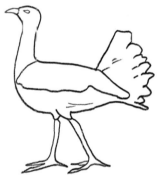

Draw a wavy line on the body. This will be the bird's wing. Add curvy lines to the tail.

6

Erase the guides around the tail. Erase the small line below the back of the wing. Add the legs and the feet as shown. Add the small curved line at the top of the legs.

7

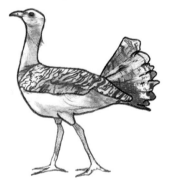

Erase the extra line at the beak area. Add an oval for the eye and the shape for the beak. Draw lines in the belly area.

8

Add detail and shading to your drawing, and you are done. Good job!

23

Roman Ruins at Gorsium

In the first century B.C., the Roman Empire ruled the western part of Hungary, known then as Pannonia. To help protect the territory from attackers, the Romans set up a military camp about 40 miles (64 km) southwest of Budapest, near the village of Tac. After the Romans closed the camp at the beginning of the second century, the city of Gorsium was built on the site by Hadrian, who later became a famous Roman emperor. Gorsium became Pannonia's religious center and the meeting place of government officers. The entire region of Pannonia, including Gorsium, was attacked many times by rival groups until the Roman Empire broke up in the late fifth century. The attacks destroyed all of Gorsium. The total area of Gorsium was about 247 acres (100 ha). Only a small part of the area has been uncovered. Among the found ruins are the remains of city walls, gates, shops, temples, the meeting hall, and church buildings. This gravestone was discovered at the Gorsium site.

1 Draw a large trapezoid on its side. This shape shows that the tombstone is at a slight angle. Look carefully at the photograph on the opposite page to help you with your drawing.

2 At the right side of your trapezoid, add the lines as shown. These lines form another trapezoid, which gives the tombstone depth. These shapes will be your guides.

3 Draw lines in and around the trapezoids as shown. The wavy horizontal lines in the middle show where the stone has been cracked over time.

4 Erase your guidelines, leaving the tombstone as shown. Draw three horizontal lines in the top section, and a rough shape in the bottom section.

5 Draw horizontal and sloping lines at the top of the tombstone. Even though it is not complete, the shape these lines make is like a triangle. Draw lines around the shape in the bottom section.

6 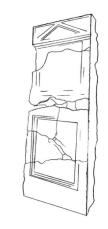 Add straight lines at the top to make more incomplete triangles as shown. In the section below this, add long and short lines as shown.

7 Look at the drawing carefully and copy the wavy lines shown. These lines are the many cracks on the tombstone. Add straight lines to the top and middle sections.

8 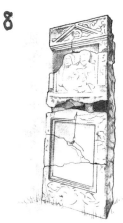 Finish the stone by adding as much detail and shading as you like. Look at the photograph again to help you add the detail of the carvings in the stone.

The Statue of Saint Stephen

A statue of St. Stephen on a horse stands on Castle Hill in Budapest. In 1906, sculptor Alajos Stróbl created the monument, which honors the founder of the Hungarian nation. Stróbl was born in 1856 and died in 1926.

Given the birth name of Vajk in 975, Stephen I was called István, or Stephen, for the bishop of Passau. From 997 to 1000, Stephen was the Prince of Hungary. He then became the nation's first king. He took the throne on December 25, 1000. He received a holy crown and cross that were sent from Rome by Pope Sylvester II, the powerful leader of the Roman Catholic Church. On this date, Hungary was born. During his reign, King Stephen spread Christianity throughout the country and made Roman Catholicism Hungary's official religion. After his death on August 15, 1083, King Stephen was made a saint.

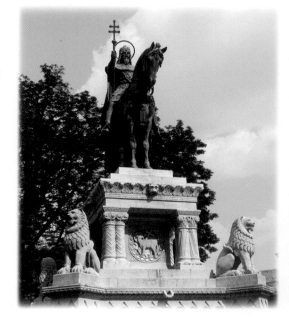

1

Begin by drawing lines and shapes as shown. Notice that the largest shape has sloping sides.

2

Add more sloping lines and two rectangles. These sloping lines help to give the shape depth. You have drawn the top part of the statue's base.

3

Add vertical and horizontal lines for columns at the base. Notice that some of the lines are slightly curved.

4

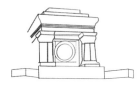

To complete the base, add rectangular shapes to the bottom as shown. Add lines and circles between the two columns.

5

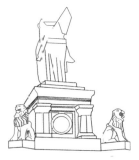

Draw two lions. Draw lines and shapes on top of the base. These will be your guides to drawing the statue of St. Stephen on his horse.

6

Look at the drawing carefully, and, using the photograph to help you, draw the lines and shapes within the guides as shown.

7

Erase guidelines, leaving the statue. Draw St. Stephen's head and face, surrounded by a halo. Draw a staff. Add tiny circles to the leg on the left. Add the picture of the animal and the cross in the circle on the base.

8

Finish the statue by adding as much shading and detail as you like.

27

Pannonhalma Abbey

Pannonhalma Abbey has stood in the small village of Pannonhalma in northwestern Hungary since 996. In that year, Stephen I's father, Prince Geza, invited Benedictine monks from Venice and Prague to build the abbey there. The abbey is a home for monks. Monks devote 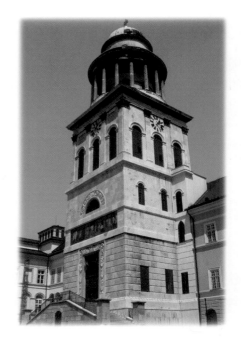 their lives to Christianity. King Stephen used the monks there to help convert Hungarians to the Christian faith. The monks also founded the country's first school there. It still exists today.

Located high atop St. Martin's Hill, Pannonhalma Abbey has been attacked by enemy armies and has been rebuilt many times over the centuries. As a result, the monastery is a strange mixture of many different architectural styles, including Romanesque, Gothic, and Renaissance. It is the oldest building still in existence in Hungary. More than 40 monks live in the abbey today, and about 320 boys study in the school.

1

Start by drawing a large rectangle. Inside the rectangle draw vertical and horizontal lines to create two shapes at slight angles.

5

Erase any extra lines. Add lines to the top, making six rectangular shapes. These are frames for the windows. Add lines for the door and frame. Add more sloping lines on the right side of the drawing.

2

Draw the horizontal and vertical lines shown. Again, the horizontal lines are at an angle. Notice that the lines do not meet at the right side.

6

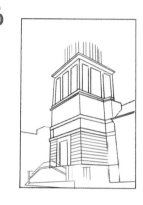

Carefully copy the shapes of the stairway and pillars at the front entrance. Use the photograph to help you. Add more sloping lines to the abbey and to the building beside it.

3

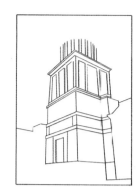

Draw 14 vertical lines close together at the top. See how they are in a curve. These are the beginning of the abbey's dome. Draw the shape on the right for the building beside the abbey.

7

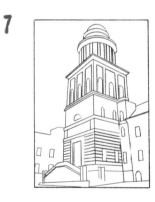

Complete the dome by adding curved lines. Add arches to the top section. Add windows to all the buildings. Add an arched doorway to the building on the right. Add horizontal lines. Add a sloping line at the bottom. Erase any extra lines.

4

Draw sloping lines across the abbey and the neighboring building. Add lines on the left side of the drawing.

8

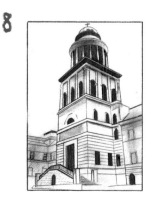

Look at the drawing and the photograph and add as much detail as you like. Finish with shading.

The Royal Palace

Hungary's first royal castle was built on Castle Hill in in Budapest in 1243 by King Béla IV of the Árpád dynasty, or family. Kings who reigned later made the Royal Palace bigger and more ornate.

Hungarian royalty lived at the palace until the Turks invaded the country in the sixteenth century. Under Turkish rule, between 1541 and 1686, the two towns of Buda and Pest were destroyed. The palace was left in ruins. When the Hapsburgs beat the Turks in the late 1600s, they built a new palace of their own. The Royal Palace was attacked at least 31 times over the years and was restored again and again. Today the castle with its 203 rooms houses the Budapest Historical Museum, the Hungarian National Gallery, and the Ludwig Museum.

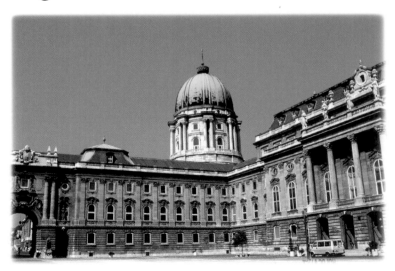

1

Draw a large rectangle. Inside it, draw two shapes, with lines at the tops, as shown. See how the shapes and lines are slightly sloping.

2

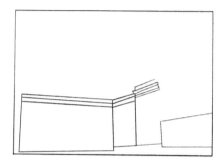

Add lines to the right of the shapes you just drew. Add three lines to make a shape at the right side of the drawing.

3

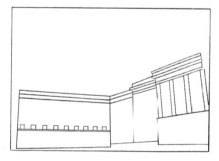

Add two lines and nine squares on the left. Add horizontal and vertical lines on the right. See how these lines slope a little.

4

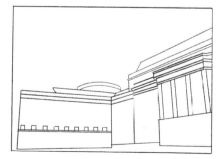

Add lines to the roofs as shown. Notice how the two lines in the middle area form a curve.

5

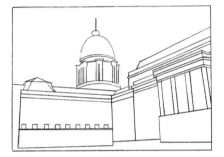

Draw the roof and lines at the left side of the drawing.

6

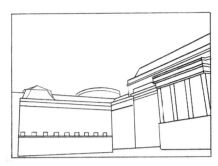

Draw the dome and the spire in the middle of the drawing as shown. Draw the vertical and horizontal lines underneath the dome.

7

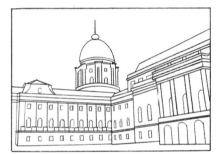

Add vertical and horizontal lines on the far left side. Add nine vertical lines to the building on the left. Draw the many rectangular windows. Add the arches on the right side.

8

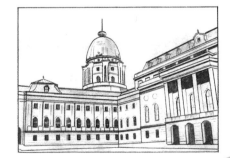

Finish by adding as much detail and shading as you like.

The Statue of Janos Hunyadi

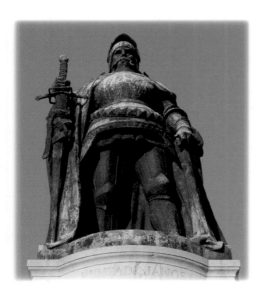

In the fourteenth century, the Turkish army tried to invade Transylvania, a region of Romania near the Hungarian border that once was part of Hungary. Janos Hunyadi became one of Hungary's greatest heroes by defending the country from the Turks' Ottoman Empire.

Hunyadi's greatest success came in 1456, when he beat the Turks at Nándorfehérvár, which is now Belgrade. Belgrade is the capital of Serbia. Belgrade lies at the intersection of the Danube and Sava rivers. This victory kept the Turks out of Hungary for 70 years until it finally fell to the Turkish armies in 1526. In the same year as his victory, Hunyadi died of the plague.

A statue of Janos Hunyadi, sculpted by Ede Margo, is part of the Millennial Monument. The monument is composed of statues representing Hungary's national heroes. It is located in Heroes' Square, the largest square in Budapest.

I

Draw two ovals. These will be your guides to drawing the statue's head and chest.

2

Draw lines coming from the large oval. Notice that one of them is slightly bent. These lines will help you to draw the legs.

3

Draw the lines shown to form the shape that will be part of the statue's arm.

4

Draw the details of the statue's cloak as shown. Don't forget the part on the top of the shoulder at the right.

5

Erase most of the large oval guide. Erase extra lines. Add lines to the top of the cloak on the left. Add a shape to the inside of the cloak on the left. Add details to the body and legs.

6

Erase the leg guides. Next draw the details for the face, the helmet, and the arm on the right. Add a wavy line between the legs.

7

Draw the statue's sword, with fingers wrapped around the front of it as shown. Add extra detail to the chest, belly, and legs.

8

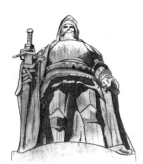

You can finish your statue with shading. Well done! You did a great job.

33

Esterházy Castle

The Esterházy family was one of the most important Hungarian noble families during the period of the Hapsburg Empire. Esterházy Castle is also called the Castle of Fertod because it stands the village of Fertod, located in western Hungary near Austria. Prince Nikolaus of the Esterházy family ordered the castle's construction. It was completed in 1766. Prince Nikolaus wanted a palace that was as grand as the palace of Versailles in France. One of the most important features of the castle is the Haydn Room. It is one of the world's most beautiful concert halls, where many performances are held today. The horseshoe-shaped castle also houses a museum, a hotel, and a school.

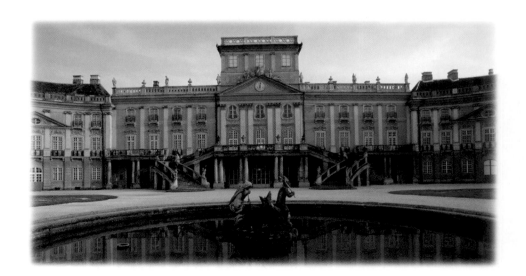

1

Begin by drawing a large rectangle. Inside it, draw two triangles, one inside the other. Around the triangles, draw a rectangular shape and horizontal lines. Part of the rectangle is hidden by the triangles.

2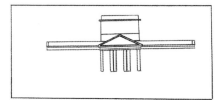

Add horizontal and vertical lines below the triangles. Draw long horizontal lines coming from both sides of the triangles. Add small vertical lines on the outer edges of these lines.

3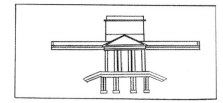

Draw lines that slope downward at the sides as shown. Next draw vertical lines that are on top of small rectangles. This shape is the top of the staircase.

4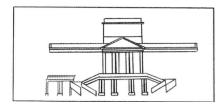

Draw four sloping rectangles on the right and left sides. These are part of the staircase. Draw the shape shown on the left.

5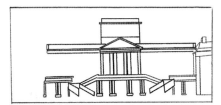

Draw lines and rectangles on the right side of your drawing. The rectangle on the top is a chimney.

6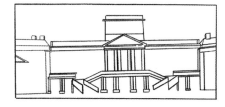

Draw the building on the left side as shown. Draw a shape toward the top part of this building.

7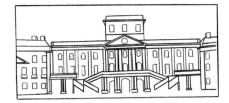

In the triangles, add a circle for the clock. Next add all the windows throughout the three buildings as shown. Some are rectangles, and some have arches. Three of the windows in the middle section are shaped like pears!

8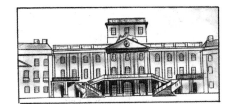

Look carefully at the drawing and the photograph and add as much detail as you like. Finish with shading.

Esztergom Cathedral

North of Budapest along the Danube River sits the town of Esztergom. It served as the capital of Hungary for 300 years, beginning in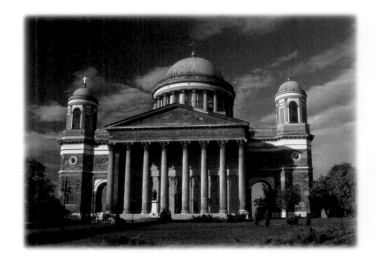
the tenth century with Prince Géza, great-grandson to Prince Árpád. Prince Géza's son, Stephen I, was born and died in Esztergom. Helping to spread Christianity throughout Hungary, Stephen I founded St. Adalbert Church there. This church was pulled down, however, and Bakocz Chapel was built on the site between 1506 and 1511. Later, Bakocz Chapel was made part of a new basilica called the Esztergom Cathedral. The cathedral's construction lasted from 1822 to 1856. The biggest church in Hungary, it is a replica, or copy, of St. Peter's Cathedral in Rome. It measures 387 feet (118 m) long and 131 feet (40 m) wide. The roof of the entrance hall is supported by eight pillars. Each pillar is 72 feet (22 m) high. The central dome is 328 feet (100 m) high.

1

Draw two triangles as shown. Add a rectangle with a horizontal line at the top.

2

Draw two shapes on either side of the main building. The one on the left is closer and leans slightly. These will be the towers.

3

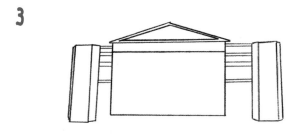

Draw horizontal lines between the main building and the towers as shown.

4

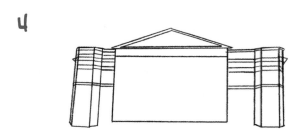

Extend the lines you drew in the last step to reach at slight angles across the towers. Make one of the lines stick out on each side.

5

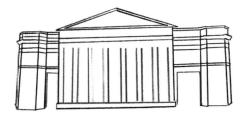

Erase any extra lines. Draw two horizontal lines, one at the top and one at the bottom of the main building. Draw 14 vertical lines for columns. Draw doors on either side as shown.

6

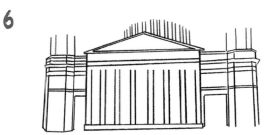

Draw a lot of short vertical lines on the main roof. They should be toward the right side and should make a curved shape. Add four lines to each of the towers.

7

Draw curved lines for the dome in the middle. Add a cross to the top. Add domes, crosses, and windows to the two towers. Add lines to the main building and arches in the doorways.

8

Use shading and detail to finish your drawing.

The Great Reformed Church

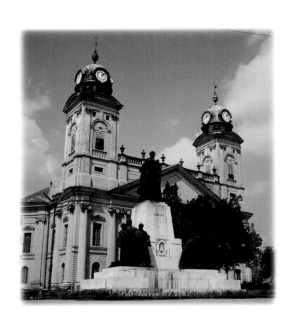

About one-fifth of the Hungarian population follows the Calvinist religion. That is about two million people. Calvinism is a form of Protestantism that was introduced in the sixteenth century. Calvinism was especially accepted in Debrecen, located in Hungary's Eastern Plain. Today, Debrecen is widely viewed as the center of Protestantism in Hungary. It is home to Hungary's largest Protestant church, the Great Reformed Church. Built in 1821, the big neoclassical building can hold up to 3,000 people.

On April 14, 1849, the church's most important historical event took place. On that date, Lajos Kossuth and the Hungarian Parliament announced Hungary's independence from Austria's Hapsburg Empire. Although Austria took back control soon after, Kossuth became a national hero. Today, choirs, bands, and orchestras perform often in the church.

1

You are going to draw the Great Reformed Church and the statues and trees around it. Start by drawing a rectangle. Draw the steps and the shape on the right.

2

Draw three figures on the left. Beside them, draw two little steps. Behind them, draw the large, two-level statue base. Draw the outline of the trees to the right.

3

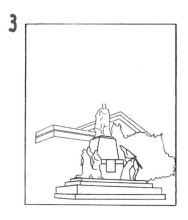

Draw the statue. Next you are going to begin to draw the church. Draw the rectangular shapes on the left. Draw the lines behind the statue that look like the tops of triangles.

4

Add to the left side of the building by drawing a vertical line and a horizontal line that meet at the bottom. Draw vertical lines inside the building. Add lines under the tree.

5

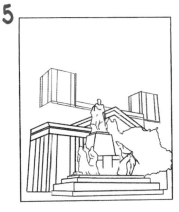

Draw the towers on each side of the building. We will connect them to the building in the next step. Draw the sloping lines between the towers. Add a small vertical line on the right.

6

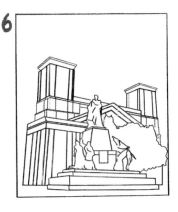

Finish the middle part of this section of the church with lines as shown. Many of the lines form rectangular shapes. Add the shapes to the tops of the towers.

7

Draw the domes on top of the towers. Add the spires, the circles for the clocks, and the curved shapes below the domes. Draw shapes for windows. Add lines for part of the building on the left.

8

Look at the photograph on the opposite page to help you when you are adding detail. Finish with shading.

39

The Chain Bridge

In 1848, Count István Széchenyi became the first minister of transport of the first independent Hungarian government. He helped to improve the country's transportation system by building railways and shipyards. He increased travel by steamship on the Danube River and paid for the first permanent bridge across the river, connecting Buda and Pest. The Chain Bridge was his most famous accomplishment. Under Széchenyi's direction, the stone suspension bridge was erected between 1839 and 1849. It measures 1,260 feet (384 m) long and 57 feet (16 m) wide and is supported by pillars, or columns. In January 1945, during World War II, German troops blew up the Chain Bridge. It was rebuilt to its original form between 1948 and 1949.

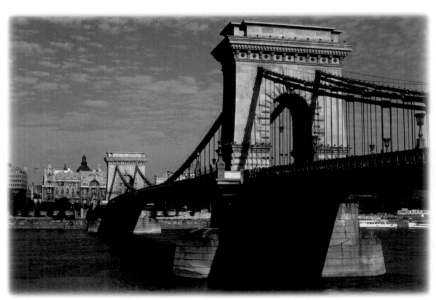

1

Draw a rectangle. Add the lines and shapes near the top of the rectangle as shown.

2

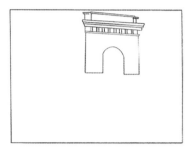

Below the shape you have just drawn, draw small vertical lines and two horizontal lines. Add the straight lines and the arch as shown.

3

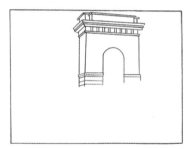

Add horizontal, vertical, and sloping lines to the top, left side, and bottom parts of the archway.

4

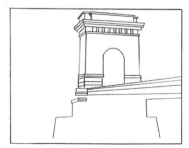

Draw long, sloping lines and three rectangular shapes at the bottom of the arch. Below this draw three rectangles. Add lines for the bridge's base.

5

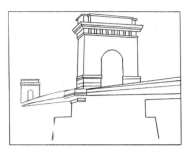

Add rectangles and sloping lines on the left side. Add the archway at the back.

6

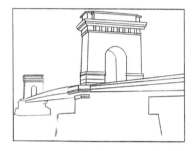

Add a curved line inside the main arch to give it depth. Add a base and a vertical line to the smaller arch in the background.

7

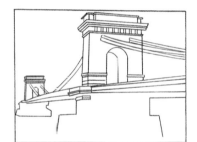

Draw curved lines coming from the arches to make the cables that support the bridge.

8

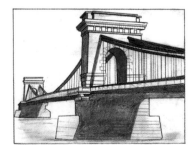

Draw the wires coming from the cables. Add more detail and shading.

The Opera House

Hungarians have always shared a love of music, including opera. In 1884, Budapest became Hungary's center of classical music with the opening of the Hungarian State Opera House.

The opera house was designed by Miklos Ybl, one of the period's best architects. The building took nine years to construct. On a balcony near the roof are statues of 16 of the world's greatest composers, including Mozart, Beethoven, and Wagner. By the entrance stand statues of two famous Hungarian composers, Franz Liszt and Ference Erkel. Erkel composed the country's national anthem. More than 15 pounds (7 kg) of gold were used to decorate the horseshoe-shaped auditorium, which seats more than 1,200 people.

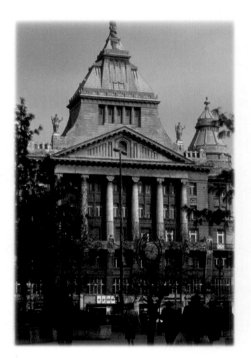

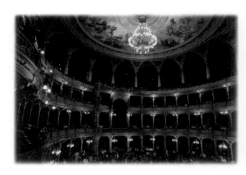

1 Begin by drawing a rectangle. Draw two triangles inside it. Add the other straight lines.

2 Draw horizontal lines and a small vertical line inside the building. Draw a vertical line at the left side and some curved lines at the right.

3 Add the six small shapes inside the building as shown. Add more curved lines to the right side. Draw straight lines on the left.

4 Draw straight lines for the columns. Add shapes for the roof on the right side of your drawing. The top of the roof is a triangle.

5 Above the center building, draw the lines to create the roof as shown.

6 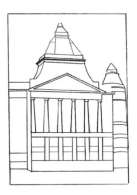 Draw straight, horizontal, and sloping lines to complete the middle roof. Add horizontal lines at the bottom of the building behind the columns.

7 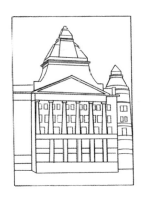 Add extra lines to the left side of the roof. Add lines to the right of the triangles. Draw many windows as shown.

8 Add as much detail as you like. You can look at the photograph to help you. Finish with shading.

43

Timeline

First century B.C.	The Romans conquer the lands surrounding the Danube River.
Ninth century	The Magyars settle in the plains by the Carpathian Mountains.
1000	Stephen I is crowned the first king of Hungary.
1526–1547	The Turks invade and conquer Hungary. The Ottoman Empire rules for more than 150 years.
1699	Hungary is taken over by Austria's Hapsburg Empire.
1867	Austria recognizes Hungary as a self-governing kingdom and the combined countries become the Austro-Hungarian Empire.
1914	The Austro-Hungarian Empire fights on the side of Germany and the Turkish Empire in World War I.
1918	After Germany is defeated in WWI, the Austro-Hungarian Empire ends and Hungary's territory is divided.
1938–1945	Hungary joins Nazi Germany in World War II. When Hungary later breaks with Germany, the German army invades Hungary. The Soviet army frees Hungary at the end of the war.
1949	Under the Soviets, Communism reigns in Hungary.
1989	Communism in Hungary ends.
1999	Hungary becomes a full member of the North Atlantic Treaty Organization (NATO).
2000	Hungary celebrates its one-thousandth anniversary as a nation.

Hungary Fact List

Official Name	Republic of Hungary
Area	35,919 square miles (93,030 sq km)
Continent	Europe
Population	About 10,000,000
Capital	Budapest
Most-Populated City	Budapest, population, about 2,000,000
Industries	Machinery, bauxite, wine
Agriculture	Corn, wheat, potatoes, sugar beets, sunflower seeds
National Anthem	"Szozat" ("Appeal")
Official Language	Hungarian
Common Phrase	*Jo napot kivanok* ("Good day")
Currency	Forint
National Holiday	St. Stephen's Day, August 20
Popular Sport	Soccer
National Dish	Hungarian goulash
Longest River	Tisza, 359 miles (578 km)
Major Lake	Balaton, 232 square miles (601 sq km)
Highest Peak	Mt. Kekes, 3,330 feet (1,015 m)
Major Religions	Roman Catholicism, Protestantism
Boundaries	Slovakia, Ukraine, Romania, Yugoslavia, Croatia, Slovenia, and Austria

Glossary

abbey (A-bee) A house for people, such as monks and nuns, who have taken vows of faith.

architects (AR-kih-tekts) People who create ideas and plans for a building or an organization.

aristocratic (uh-ris-tuh-KRA-tik) Having to do with a member of the upper class.

basilica (buh-SIH-lih-kuh) An early Christian church building.

bishop (BIH-shep) A leader of a faith, such as Roman Catholicism, who is ranked above a priest.

cathedral (kuh-THEE-drul) A large church.

chemicals (KEH-mih-kulz) Matter that can be mixed to cause changes.

Christian (KRIS-chun) Someone who follows the teachings of Jesus Christ.

coat of arms (KOHT UV ARMZ) A picture, on and around a shield or on a drawing of a shield, that stands for a family or a country.

Communist (KOM-yuh-nist) Referring to a system in which the government owns all property and goods, which are shared equally by everyone.

declined (dih-KLYND) Became less in amount.

democracy (dih-MAH-kruh-see) A government that is run by the people who live under it.

designed (dih-ZYND) Planned the form of something.

domestic (duh-MES-tik) Relating to one's own country.

dynasty (DY-nas-tee) A line of rulers who belong to the same family.

ethnic minorities (ETH-nik my-NOR-ih-teez) Groups of people whose race, beliefs, or practices are different from those of the larger part of the population.

export (EK-sport) A good sold by one country to another.

industry (IN-dus-tree) A business in which many people work and make money producing a particular product.

invested (in-VEST-uhd) Put money into something, such as a company, in the hope of getting more money later on.

monarchy (MAH-nar-kee) A government run by a king or a queen.

monastery (MAH-nuh-ster-ee) A house where people who have taken vows of faith live and work.

monument (MON-yuh-mint) Something built to honor a person or an event.

neoclassical (nee-oh-KLA-sih-kul) Referring to a return to things classical, usually in the arts and building plans.

nomadic (noh-MA-dik) Roaming about from place to place.

orchestras (OR-kes-truhz) Groups of people who play music together.

parliamentary (par-lih-MEN-tree) Relating to a parliament, or the lawmakers of a country.

permanent (PER-muh-nint) Lasting forever.

petals (PEH-tulz) Parts of a flower.

prime minister (PRYM MIH-nih-ster) The leader of a government.

Protestantism (PRAH-tes-ten-tih-zum) A faith based on Christian beliefs.

province (PRAH-vins) One of the main parts of a country.

republic (ree-PUB-lik) A form of government in which the people elect representatives who run the government.

restored (rih-STORD) Put back; returned to an earlier state.

revolts (rih-VOLTS) Fights against the authority of a government.

revolution (reh-vuh-LOO-shun) A complete change in government.

Soviet Union (SOH-vee-et YOON-yun) A former Communist country that reached from eastern Europe across Asia to the Pacific Ocean.

spire (SPYR) A tall, narrow structure that comes to a point at the top.

suspension bridge (suh-SPEN-shun BRIDJ) A bridge that hangs down from cables.

symbolizes (SIM-buh-lyz-ez) Stands for something else.

symbols (SIM-bulz) Objects or pictures that stand for something else.

textiles (TEK-stylz) Woven fabrics or cloths.

transportation (tranz-per-TAY-shun) A way of traveling around.

World War I (WURLD WOR WUN) A war fought between the Allies and the Central Powers from 1914 to 1918.

World War II (WURLD WOR TOO) A war fought between the Allies and the Axis powers from 1939 to 1945.

Index

Web Sites

Due to the changing nature of Internet links, PowerKids Press has developed an online list of Web sites related to the subject of this book. This site is updated regularly. Please use this link to access the list:
www.powerkidslinks.com/kgdc/hungary/